To Renbrook—

MONKEY BOY TO LUNCH LADY

THE SKETCHBOOKS OF JARRETT J. KROSOCZKA

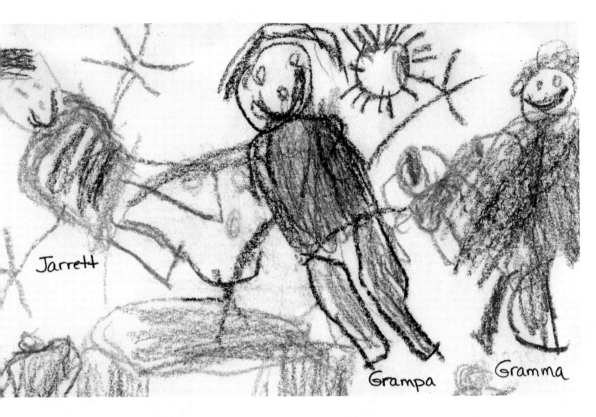

Jarrett

Grampa

Gramma

THE JOSEPH AND SHIRLEY KROSOCZKA MEMORIAL YOUTH SCHOLARSHIPS

My grandparents, Joseph and Shirley, played an integral role in my life. And that is a massive understatement! Aside from the monumental task of taking me in and raising me as their own, they were always very supportive of my creative efforts. They were brave enough to send me to college to study art, and long before that, they enrolled me in classes at the Worcester Art Museum. From sixth grade on, I took classes in cartooning, animation, illustration, and drawing. Those classes introduced me to peers who shared similar interests and taught me that a career in the arts was a possibility.

I was lucky to have my grandparents raise me and luckier still that they had the resources to enroll me in art classes. After their passing, I realized that many kids in my hometown were in similar family situations, but with caregivers who might not be in the position to send them to art classes. To honor my late grandparents and provide opportunities for young artists, I instituted the Joseph and Shirley Krosoczka Memorial Youth Scholarships at the Worcester Art Museum. Regardless of where these young artists take their careers, an education in the arts will enrich their lives and help them become more engaged critical thinkers. I am overjoyed that the "Joe and Shirl Scholarships" can help make that a reality.

Proceeds from this book will benefit the Joseph and Shirley Krosoczka Memorial Youth Scholarships at the Worcester Art Museum. Also look for an online charity auction to go live every Cyber Monday (the Monday after Thanksgiving) at www.studiojjk.com/joeandshirlscholarships.html.

INTRODUCTION

Many years ago, when I was in second grade, I did the kind of silly thing second graders are prone to do. After watching an episode of *The Rocky and Bullwinkle Show* (a GREAT animation made for TV even though it is extremely poorly animated—YouTube some episodes to solve that riddle), and seeing the dastardly Snidely Whiplash on *Dudley Do-Right*, in honor of Snidely's outstanding villainous moustache, I rather impulsively took out my mother's fat, black, permanent china marker and drew a huge, curly villainous moustache on my face. I proudly showed my mom, who let out a strangled scream and then vigorously tried to get the moustache off my face with sundry soaps and cleaners. She could get the outer layer off, but a quite visible ghost of the moustache stubbornly remained. This meant I had to go to school for a full week before the moustache eventually, and with the goodness of time, worked itself off my face. My mother, though initially shocked, thought this was all quite funny. Of course I had a lot of explaining to do to my classmates as to why, exactly, I had this faded, huge curly moustache on my face.

Jarrett's books and stories remind me of moments like these, when kids act wild and impulsive and crazy and joyful and do really funny things. Our minds are really different when we are kids, and Jarrett's books capture those feelings. He manages to get into the imagination of the type of kid I was in school. Kids who would have thought that *Lunch Lady* was super cool and hilarious and collected all the books (BTW: I wish *Baghead* had been around when I drew that moustache. It would have saved a LOT of explaining.). I have had the real pleasure of knowing Jarrett since he was just such a kid and have gotten to watch him draw. Watching his evolution as an artist and writer has been one of the deepest pleasures of my life. It has been like watching a rough pencil sketch get cleaned up and perfected into a full-color, exuberant painting and then having that painting join others to make the wonder of a finished book. Jarrett also gave my granddaughter Samantha her very first rock concert: PUNK FARM! And I will always be in his debt for that.

In case you didn't know it: Sketches are the best! I like them better than finished-up and tidy artworks. They are like looking deep into the artist's mind and following how his or her imagination works. Sketches are lively and playful, the artist's first wild thoughts, the dancing skeletons of ideas of how things can look before he or she gets down to the serious business of finishing and making it all look tidy and professional. Sketches are often unruly and rough, but in a good way. Like play wrestling with a friend. The artist is wrestling with the characters, trying to get them to behave and do what he or she wants. I often imagine Jarrett arguing with his sketches to behave. And sometimes the sketches win! That's what makes Jarrett a cool artist.

—MARK LYNCH

Teacher, field ornithologist, writer, radio show host, and moustache sketcher.

HELLO, MONKEY BOY

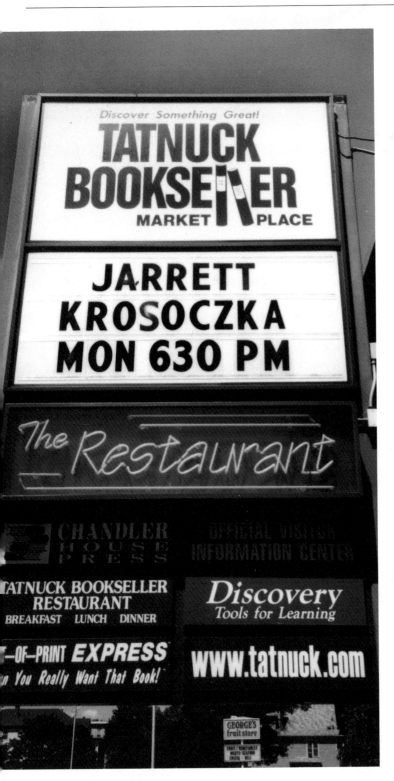

ABOVE: Tatnuck Bookseller put my name on their marquee ahead of my event there. Family members had called to tell me the store had done so, but seeing my name "in lights" in person for the first time was exhilarating!

Waiting for your first book to be published is like having your Christmas presents put out in May and you have to wait until December 25th to open them. Publishing, I would quickly learn, is a slow process. I remember the day, and the days leading up to it, of *Good Night, Monkey Boy*'s release so clearly. Every step of the way, as materials would come back from Random House, I was giddy with excitement—my name would be on the spine of a book! I had an ISBN!! Then one day, a large padded yellow envelope arrived on my doorstep. I instantly recognized the Random House logo, but I wasn't expecting a package. I picked up the envelope and froze dead in my tracks, my blood pulsating at a breakneck pace. There was something sturdy in this envelope. It wasn't floppy like all the previous packages. This was . . . a book!

On the stoop, I tore open the package and there before me was an advanced copy of my first published book. Monkey Boy's grin couldn't compete with mine. June 12, 2001, couldn't come soon enough.

On the day my first book was published, I made my way to a bookstore and approached the information booth. "Excuse me," I said. "I'm looking for a book. I believe it came out today. I don't know the author's name, but I know the name of the book."

"What is it?" asked the store clerk, ready to help.

"It's called *Good Night, Monkey Boy*."

The clerk typed the letters into the computer, hit the return key, and grimaced.

"What's the matter?" I asked.

"The author. He has a really weird last name."

"Oh, really? What is it?" I enjoyed watching the clerk struggle through and butcher my last name. But they had a few copies!

I followed the clerk into the children's section and under "K," he pulled out a copy of my book. It was official. I was a published author/illustrator with a book in a store. I brought my copy to the cashier, put the book down on the counter and placed my credit card just above my name on the cover. I pushed the book across to the woman working the register.

"Well this looks like a cute book," she said with a smile.

My instincts were to say, "THANKS!" I was eager for positive reinforcement. But instead, I played it cool.

"Yeah—it looks pretty good." She ran my card, bagged my book, and handed it over. It would be some time before I'd be recognized at airports. (For the record, even though I have been recognized at airports after conventions, the previous sentence was meant as a joke).

The book was launched at an event at Tatnuck Bookseller in my hometown of Worcester, MA. They put my name up on the marquee and even spelled my last name correctly. Leading up to the event, I was interviewed on WICN, Worcester's NPR affiliate, by my old friend and former Worcester Art Museum instructor, Mark Lynch. I was also interviewed by the *Worcester Telegram & Gazette*. This is the paper that printed a comic of mine when I was in the 9th grade and the paper I used to tear apart on a daily basis for my *Calvin and Hobbes* fix. The night of the event came and I didn't know what to expect. I'd at least have my family and a few friends in attendance. It was beyond anything my wildest dreams could have conjured. I arrived at the store twenty minutes early and they had already sold out of the two hundred copies they had in stock. Everyone I had ever known was there. My entire family, counselors and campers from the Hole in the Wall Gang Camp, friends I grew up with and their parents, high school teachers, college friends, my pediatric dentist, and my first-grade teacher, Mrs. Alisch. Mrs. Alisch barged in,

pushed herself to the front of the line, and proclaimed, "I taught him how to read!"

In the fall after *Good Night, Monkey Boy* was published, I received a letter in the mail that would forever shift my perspective on what I did for a living. It was from a mother whose son's favorite book was mine. In fact, he loved it so much that he requested a Monkey Boy birthday cake. Included with the letter was a photograph of her two-year-old son blowing out the candles on a cake that was a re-creation of my book in frosting. (The cake looked delicious.) When I got this letter, I realized something. My books were no longer just for me. They weren't just something I'd show to my grandparents, family, or friends. My books were out there and they had the power to affect kids' lives. Choosing the style of your birthday cake is a big decision—this kid would have this photograph in his family photo album for all time. I framed the picture and put it above my drafting table to remind me just who I was working for. The photo remains in my studio to this day, hung with pride.

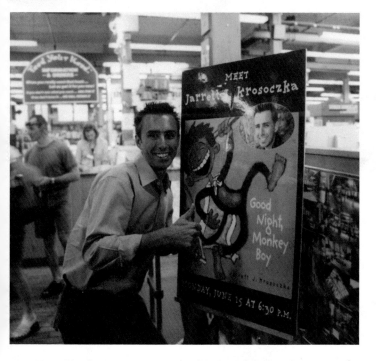

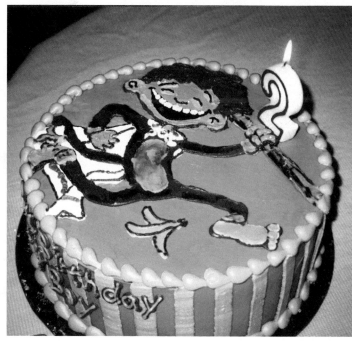

ABOVE (LEFT): Having a poster advertising my book signing was something I had always dreamt about. Whenever I saw advertisements for upcoming events in stores, I hoped that I would someday see a similar sign with my book on it.

ABOVE (RIGHT): Monkey Boy garners high praise as a child's birthday cake selection.

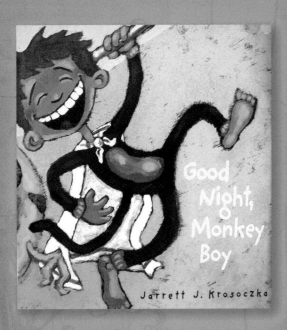

Good Night, Monkey Boy
June 12, 2001
Knopf Books for Young Readers

After graduating Rhode Island School of Design in 1999, I delayed real life by returning for another summer as a counselor at the Hole in the Wall Gang Camp in Ashford, CT. That fall, I set up my studio in Somerville, MA. I was submitting work to publishers and getting rejected at every turn. To make ends meet, I taught art courses and returned to work at the Hole in the Wall Gang Camp for their fall weekend programs. It was at one of these weekend retreats that Conor, one of my campers, engaged me in a staring contest. I called him "Monkey Boy" and he proceeded to spend the rest of the weekend as a monkey. When we discovered monkey pajamas in the theater's costume room for a skit we were working on, the idea of *Good Night, Monkey Boy* took shape in my head. A month later I would land a meeting with Knopf Books for Young Readers, and of all the projects I had to show them, it was *Monkey Boy* that they liked enough to offer me a book contract.

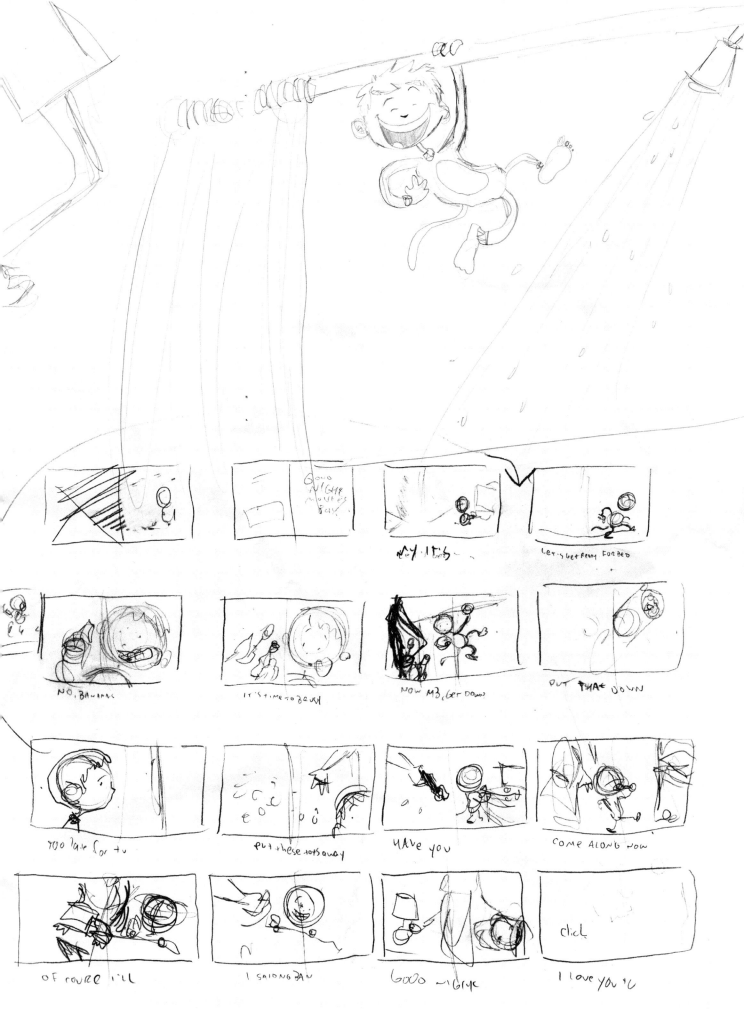

Baghead
September 10, 2002
Knopf Books for Young Readers

When I was a junior in high school in
1994, my art teacher, Mr. Shilale, gave us an
assignment—draw a brown paper bag. Being
someone who always tried to tell stories with
his pictures, I cut a face into my paper bag.
Four years later, for an independent study at
RISD, I wrote a book called *Josh Had a Bad
Haircut*. At one point in the book, the main
character attempts to hide his bad haircut
by wearing a brown paper bag on his head.
The book was rejected by every publisher
who read it, but my Knopf editor would later
suggest I write a story about the boy wearing
the paper bag who kept popping up in my
sketchbooks. This was an intimidating task. I
was already nervous about my second book.
A few proposals had already been passed up
and what if I wasn't able to deliver? The first
draft of what would become Baghead was
written entirely in rhyme. Really, really bad
rhyme. I shifted gears and told the story with
straight prose. While that second draft wasn't
stellar, my editor saw enough potential to
offer me a contract for my second book.

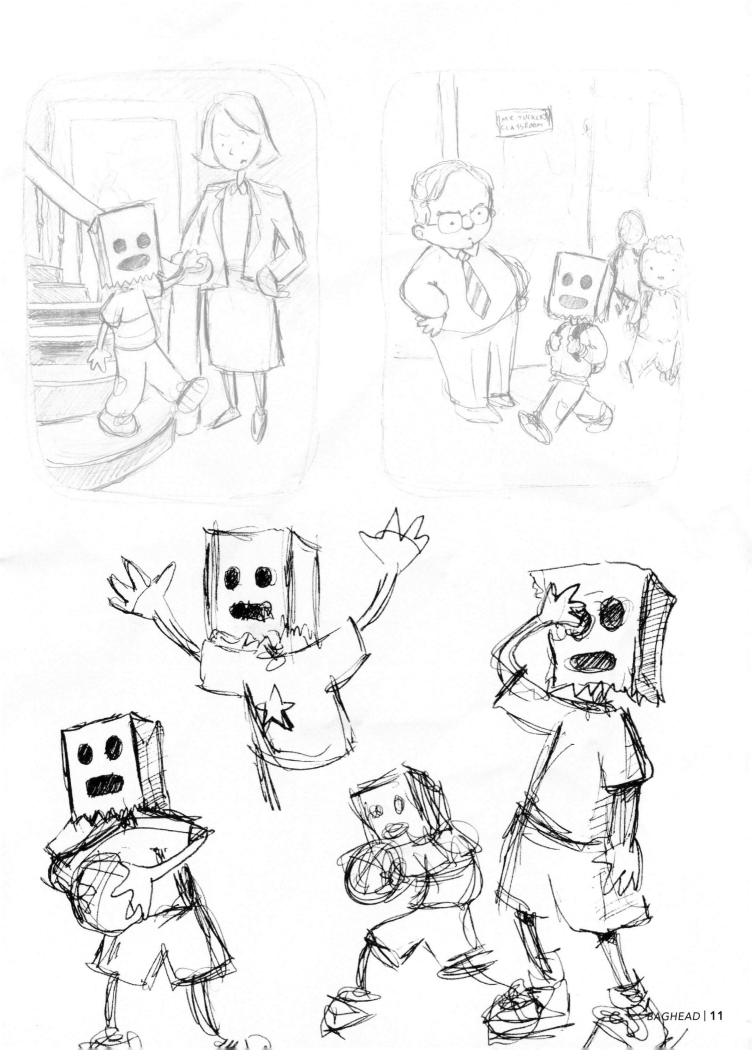

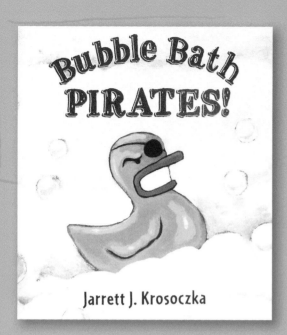

Jarrett J. Krosoczka

Bubble Bath Pirates!
March 10, 2003
Viking Children's Books

I was working on my third book and had plenty of ideas, but no clue what to do with any of them. I was visiting my older sister when her two youngest boys were acting rather hyper as she was trying to get them off to the bath. It was just a few days after Halloween and there were pirate costumes strewn across the couch. *Bubble Bath Pirates!* would soon be sent to my editor for consideration. In the initial draft, the boys didn't want to take a bath. But while *Bubble Bath Pirates!* is similar in theme to *Good Night, Monkey Boy*, I didn't want to just retell the same book with a new cast. So instead of being reluctant about their nighttime ritual, the young buccaneers are ecstatic about it. If there is one story element I could change, I'd reconsider the ending. What mother in her right mind offers ice cream to her kids after they've taken a bath? At the time of writing the book I was twenty-three years old and without children of my own . . .

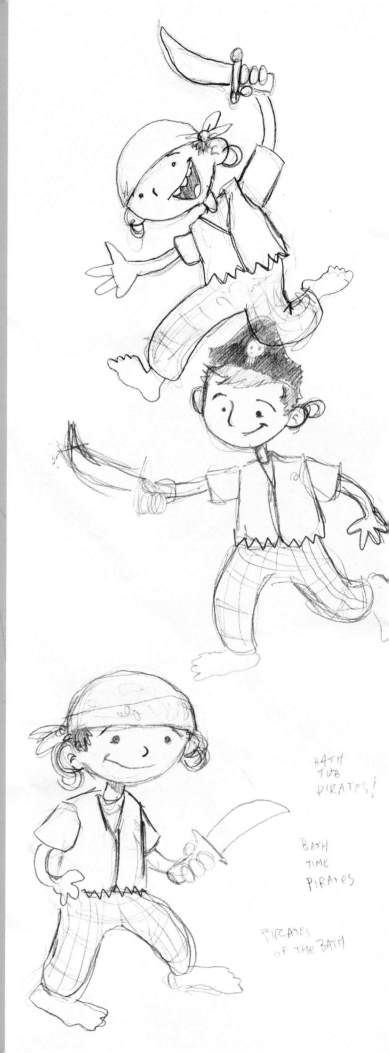

BATH
TUB
PIRATES!

BATH
TIME
PIRATES

PIRATES
OF THE BATH

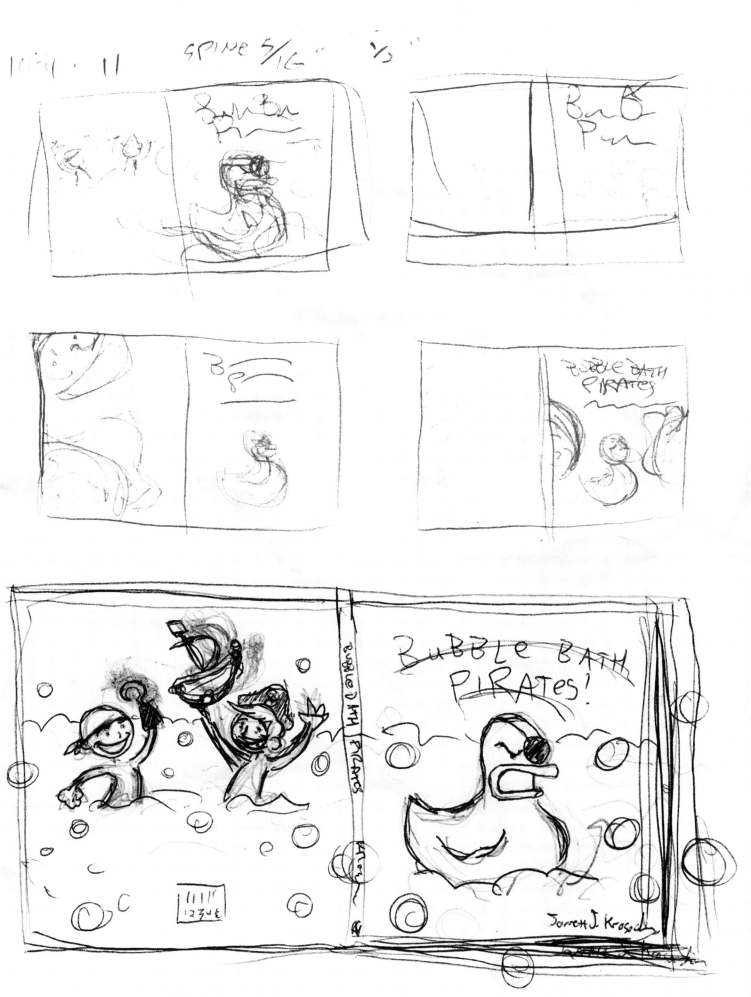

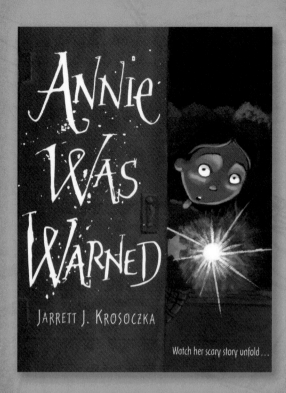

Annie Was Warned
August 26, 2003
Knopf Books for Young Readers

I was working on such vibrant, energetic picture books and I wanted to try something different. I painted a girl with blue hair creeping across an ominous graveyard and wrote a sentence—"Annie was warned." The problem was, I couldn't come up with a decent second sentence. For a few years, Annie lived in my sketchbook until one day inspiration hit and I came up with an ending for the book. With *Annie Was Warned*, it was the finale of the book that I developed first and then I worked backward from there. That was an important lesson for me as an author. You don't need to come up with the events in the story in the same order in which your reader will eventually read them. As you rewrite, you can rearrange the events as you see fit for the story.

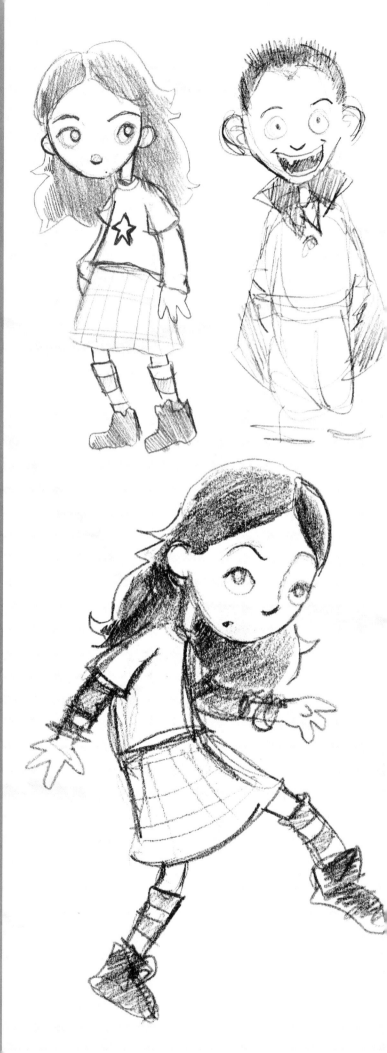

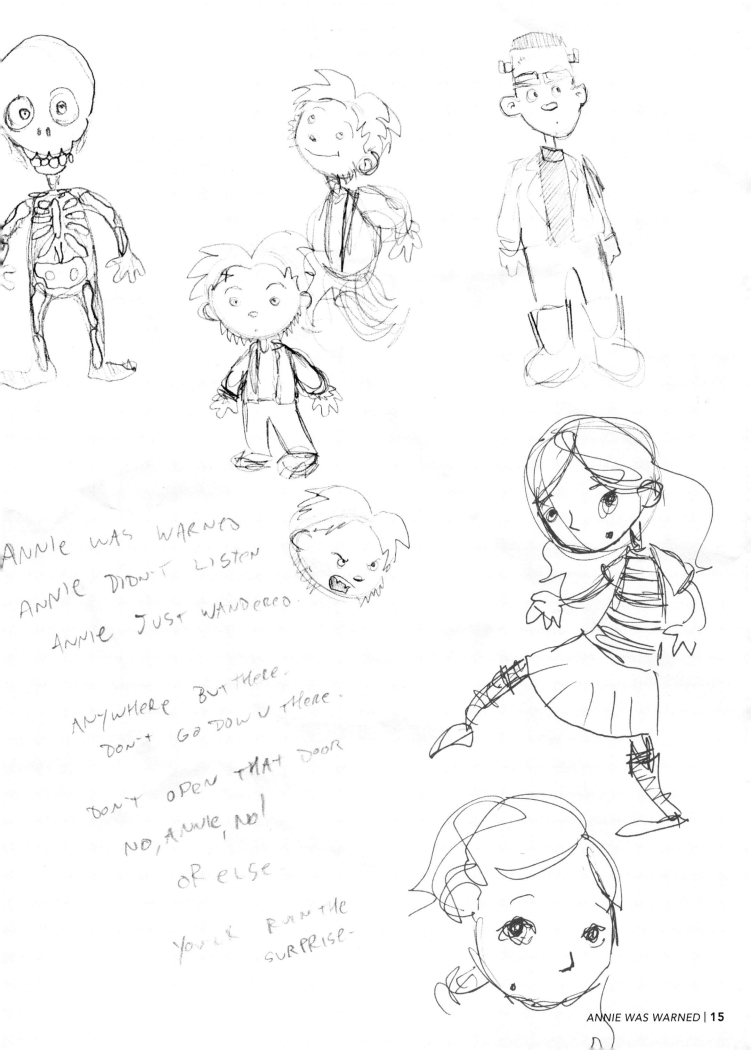

ANNIE WAS WARNED
ANNIE DIDN'T LISTEN
ANNIE JUST WANDERED.

ANYWHERE BUT THERE.
DON'T GO DOWN THERE.

DON'T OPEN THAT DOOR
NO, ANNIE, NO!

OR ELSE.

YOU'LL RUIN THE
SURPRISE.

Max for President
July 13, 2004
Knopf Books for Young Readers

When I was in New York City delivering the artwork for *Annie Was Warned,* I visited an elementary school in New Jersey. There was a class election going on and the hallways were filled with students' campaign signs for class president. One poster simply read, "Max for President." That would make for a great book title, I thought to myself. By the end of the day, I knew who would win and who would lose in the election found within *Max for President.* Sometimes stories come to you when you least expect it, and you need to be prepared for these moments. While I had other stories that were jockeying to be the next book submission, the one about Max just fell together very quickly. And it was serendipitous timing, too—the book was released in time for the 2004 presidential election. The *New York Post* posted this review: "Krosoczka offers an example of bipartisanship grown-up politicians would do well to follow."

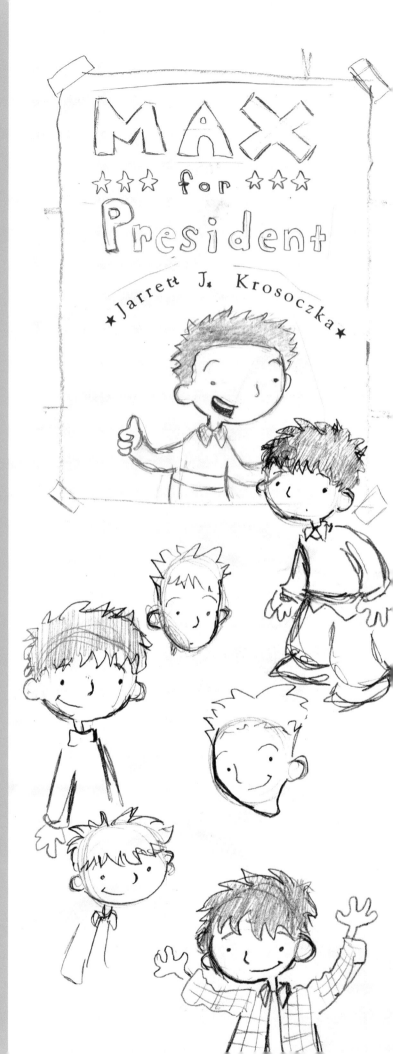

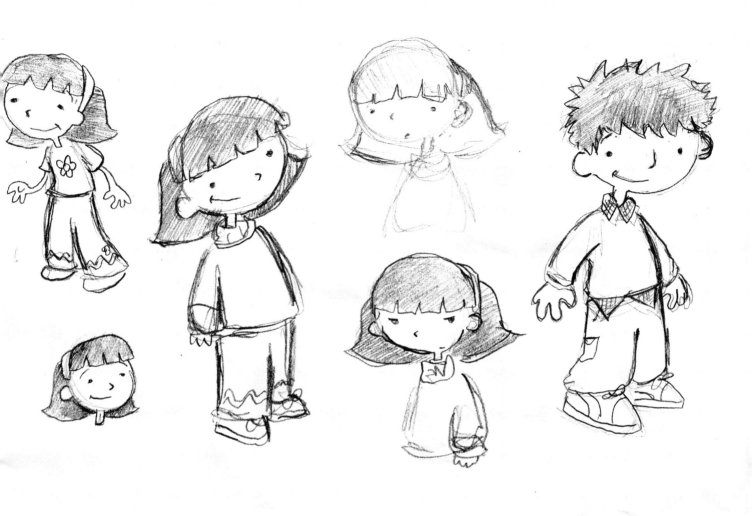

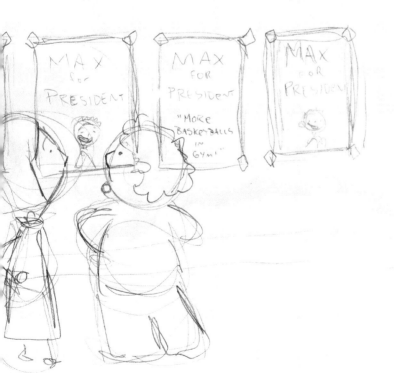

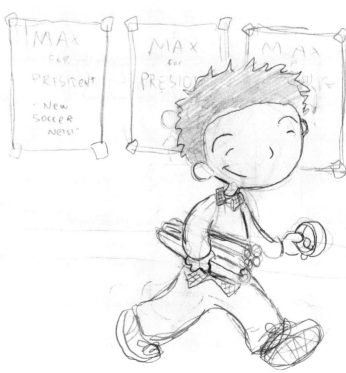

POST–PUNK FARM

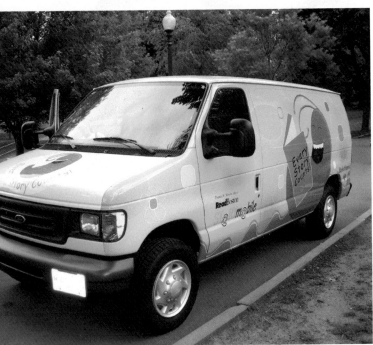

ABOVE (TOP): Rocking out down at the farm.

ABOVE (BOTTOM): I was so honored to learn that ReadBoston wanted to showcase Slug on the side of their new summer reading van. The ReadBoston StoryMobile brings books to inner-city children who might not otherwise have access to literature.

By the time *Punk Farm* was published in 2005, I had begun visiting schools frequently, accepting invitations in Texas, Virginia, and all across New England. To promote *Punk Farm*, I hit the entire west coast—from Seattle to San Diego. I was covering more ground with the passing years and learning that a successful career as an author/illustrator involved time on the road as well as time in the studio. I was visiting every store and library that would have me. Sometimes the events were blockbuster; sometimes I was lucky if a single kid happened to be in the store. I felt like an emerging band, traveling from town to town, playing club after club. The wildest aspect for me was seeing the incredible projects from kids and teachers that were inspired by my books. One school re-created the *Punk Farm* barn for my author stage. One kid drew every single character from my books rocking out together in a band. Kids would turn up to my events dressed as *Baghead* and teachers would get together and arrive as *Punk Farm*. I received pictures from *Punk Farm* birthday parties and even a *Punk Farm* baby room! Librarians would include my characters in their libraries' murals. Art from *My Buddy, Slug* was featured on ReadBoston's StoryMobile that brought books to kids across the city of Boston. With the advent of YouTube, readers would even send me fan videos and parents would send clips of their kids reading my books. It was all so surreal, incredible, and reassuring.

Shortly after *Punk Farm* was published, I was contacted by a Hollywood producer who was interested in adapting my book for the screen. At first I was skeptical. I flew out to Los Angeles for a face-to-face meeting and when I liked what the producer had to say, I realized I couldn't go this alone. I took on representation from Writers House for my books and the Gotham Group for film and TV rights. DreamWorks Animation optioned the film rights and the announcement made the front page of *Variety*. That's not the way Hollywood stories were supposed to go—a big deal right out of the gate. But this is how Hollywood stories do go—it all fell apart within a year. DreamWorks Animation opted not to make the movie. But it still catapulted my career in a big way. Even more exciting than all of this was the news that kids of Wisconsin and Abilene, TX, voted *Punk Farm* their favorite book of the year. I visited Abilene and read *Punk Farm*

to an auditorium of 1,000 first and second graders. It was my stadium-status moment.

When *Lunch Lady* was coming together as a book, I hit the streets of Los Angeles, meeting with all sorts of production companies. When my management at Gotham came on as producers for a live-action adaptation of the book series, they asked me who I envisioned donning the rubber yellow gloves. At my suggestion, they sent an advance copy of *Lunch Lady and the Cyborg Substitute* to Amy Poehler. She called the next day to express her interest. Amy was the only actor we sent the book to and within twenty-four hours she was on board! She brought the project to Universal Pictures and they optioned the film rights to the *Lunch Lady* book series. The announcement made the cover of *The Hollywood Reporter*. Again, Hollywood stories just don't go this way. As I'm writing this, the movie is still in development. I know from experience that this is the best news anyone could ask for.

Hollywood buzz aside, I still needed to work hard. I continued to hit the road and logged long hours in the studio. In the first year of *Lunch Lady*'s launch, I had over one hundred events in schools, libraries, and bookstores. I certainly didn't expect with the launch of the *Lunch Lady* series that the kids who read my picture books when they were first published were now older and ready

for longer books. I also learned that kids in the middle-grade audience were much more social in their reading habits. Their word-of-mouth backing of the series spread like wildfire. Letters came in from parents and teachers informing me that the *Lunch Lady* books were hooking their reluctant readers. Kids sent me ideas for *Lunch Lady* gadgets. And when I visited schools, I would be feted with freshly baked brownies by the lunch ladies. But just as I received that photo of the Monkey Boy birthday cake, I would be reminded once again just why I do what I do. *Lunch Lady and the Cyborg Substitute* would take home the award for Third to Fourth Grade Book of the Year in the Children's Choice Book Awards, the only national awards program where the nominees and winners are selected by kids themselves. It was the readers who put my name up in lights in Times Square. I was lucky enough to win a Children's Choice Book Award again in 2011. The trophies I received sit on a shelf in my studio. Not as a reminder of an accolade, but as a reminder of just who I work for.

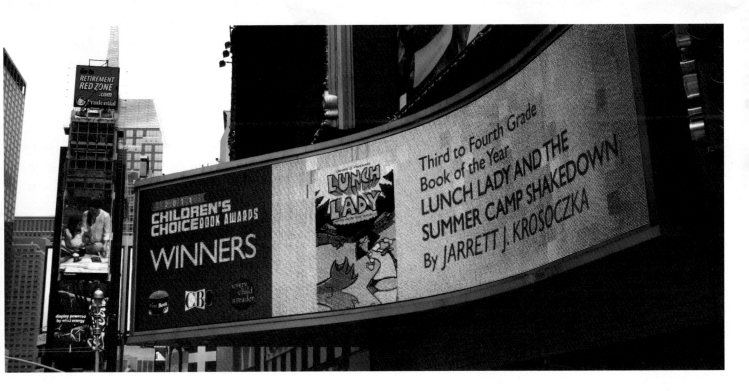

ABOVE: In 2010 and 2011 Lunch Lady books took home trophies for Third to Fourth Grade Book of the Year in the Children's Choice Book Awards. I was thrilled to see my name scroll across the Toys "R" Us Geoffrey Tron screen in Times Square, but even more thrilled to know that the votes of my young readers were responsible for getting it there.

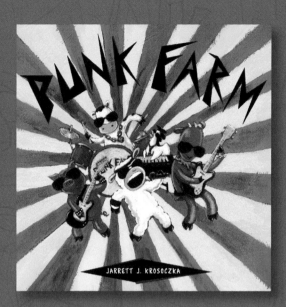

Punk Farm
April 26, 2005
Knopf Books for Young Readers

In 2001, I submitted *Piggy Pig*, a book about a pig who didn't like to get dirty. Knopf turned the book down, citing the overabundance of farm animal books and the fact that this book didn't stand out from the crowd. I was disappointed at the time. I went on to work on other stories and frequented the rock shows put on by my younger sister and brother. I started work on a book about a kid rock star. After a year, I still didn't know where to take the story. In the summer of 2003, I returned to volunteer a session at the Hole in the Wall Gang Camp, and to get our campers onto the front porch and ready for their activities, I would blast punk music. The campers would transform the porch into a stage, lip-syncing and playing air guitar. Soon, they came up with a name for their band, made instruments out of cardboard, and plastered the camp with posters advertising their upcoming "stage night" performance. By the end of the week, the girls in the neighboring cabin developed crushes, the guitarist threatened to go solo, and the drummer had an emotional breakdown. I returned home from camp and realized how much humor could be found in a band rather than a singular rock star. And when I came across the character designs from *Piggy Pig*, it all clicked. *Punk Farm* was born!

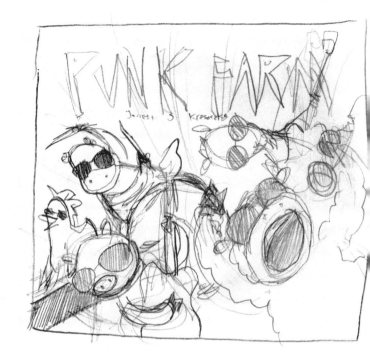

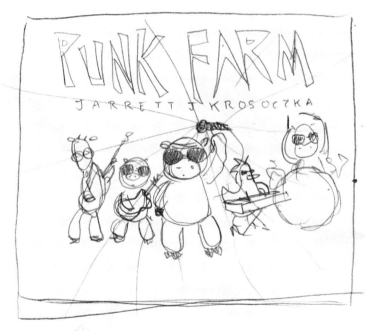

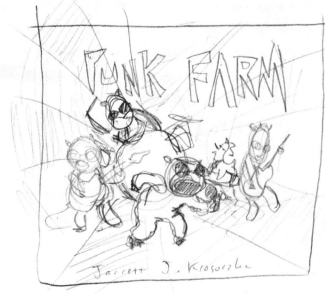

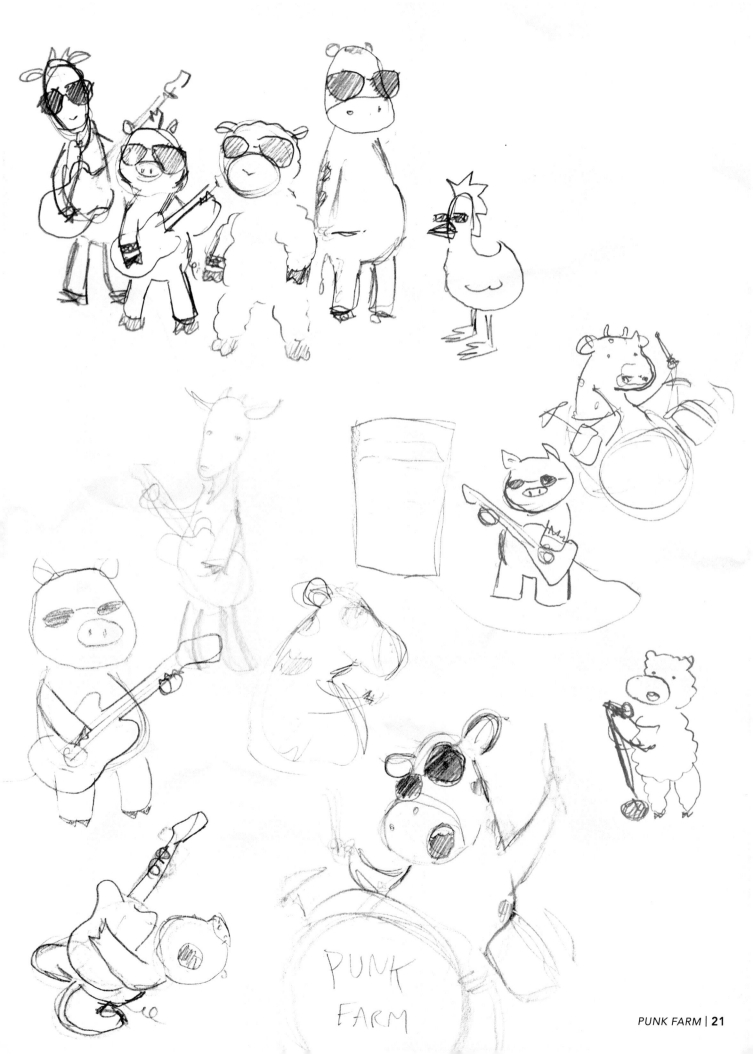

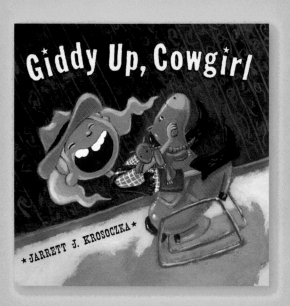

Giddy Up, Cowgirl
February 2, 2006
Viking Children's Books

After so many years of traveling down to Texas for school visits, I was bound to write a book with Southern flair. At book signings, parents had been asking me to write a book in the vein of *Good Night, Monkey Boy*, but with a female protagonist. I also wanted to illustrate everyday scenarios in a neighborhood—at the grocery store, the post office, etc. This all came together to create *Giddy Up, Cowgirl*. While it isn't one of my more popular books, I have a fondness for it—especially now that I am the father of a young girl who likes to help out.

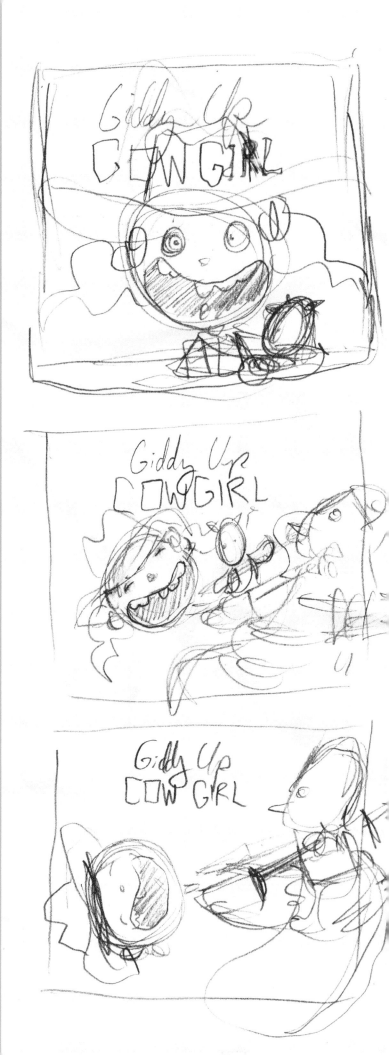

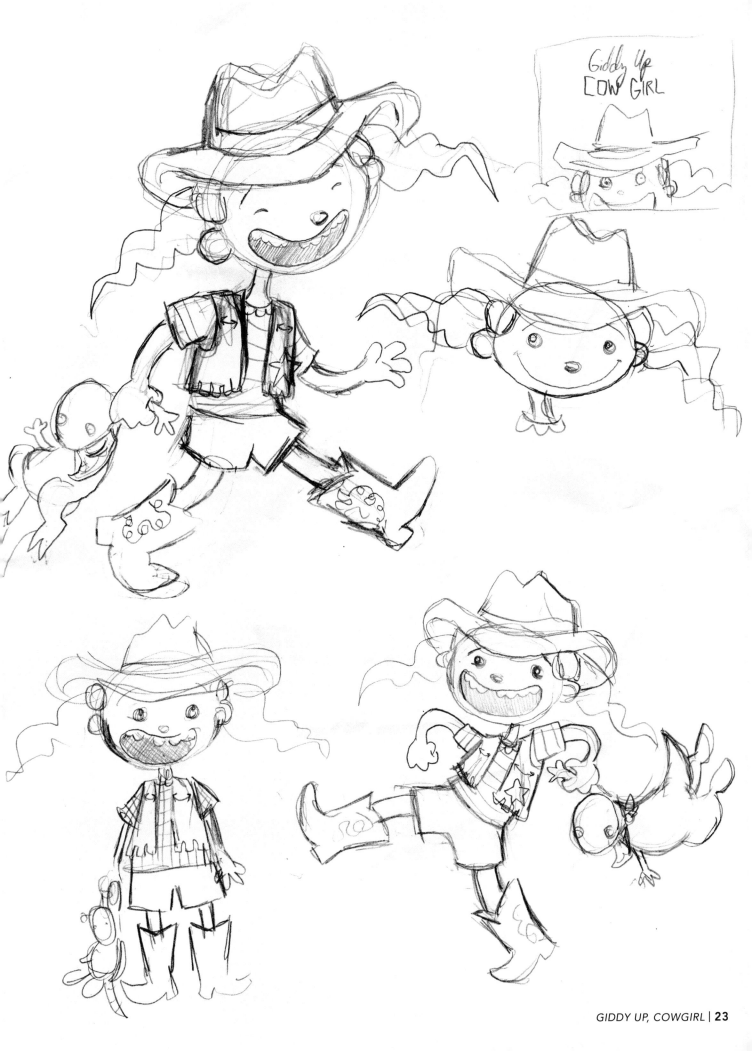

Giddy Up
COW GIRL

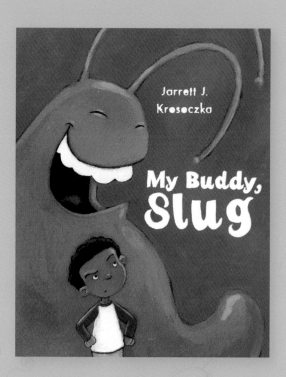

Jarrett J. Krosoczka

My Buddy, Slug

My Buddy, Slug
September 12, 2006
Knopf Books for Young Readers

My Buddy, Slug was a long time in the making. I first wrote a story about a talkative slug in 1997 in a course on picture books at RISD. That book, *"Hello," Said This Slug*, was the first book I submitted to publishers. I have a dozen rejection letters for that book in a file. When I was getting those first few books published, I thought it would be easy to get Slug picked up. I was wrong. The story still had plenty of issues and my newfound accolades wouldn't mean anything if the story was in poor shape. I put the book away for a few years and then looked at it again with fresh eyes. I didn't blame any of the publishers who rejected the book; I would have done the same, it had so many problems. I rewrote the book, giving it a new title, and submitted it to Knopf. I braced myself for another rejection. But my editor called with an offer to publish *My Buddy, Slug*.

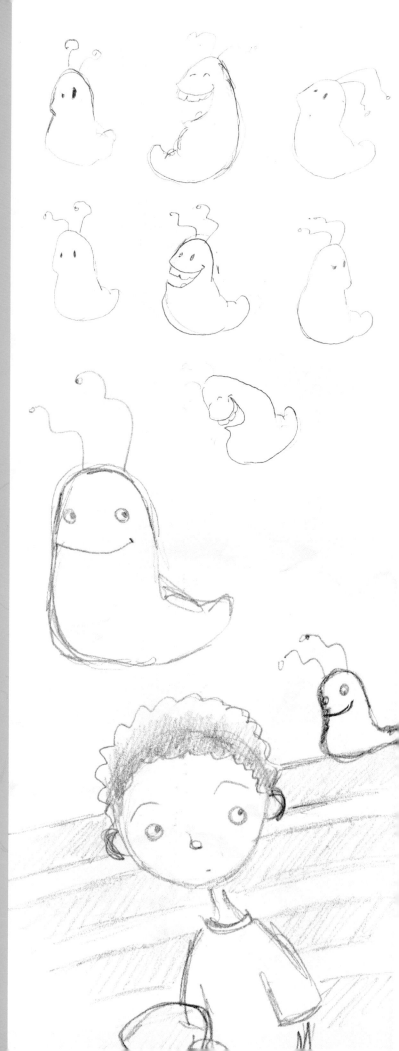

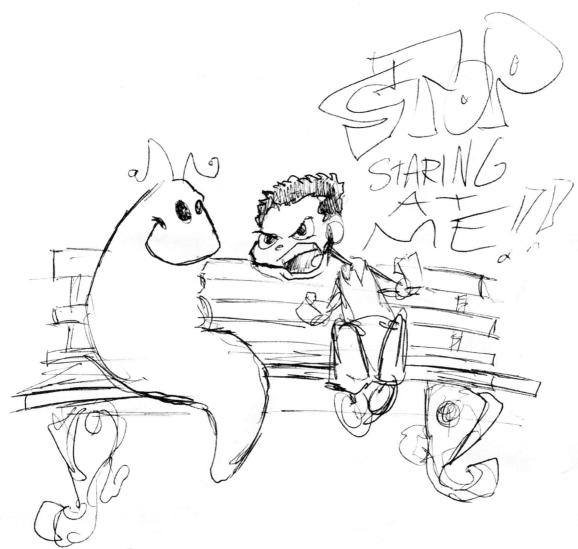

My family loved Slug.
"Alex honey," my mother said,
"We thought it would be so
nice if Slug slept over tonight."

Slug smiled.

I didn't.

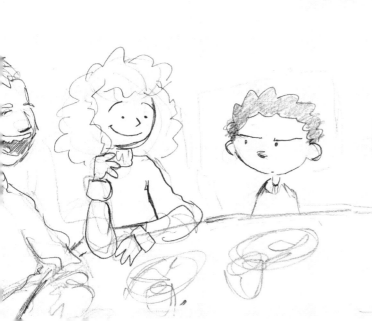

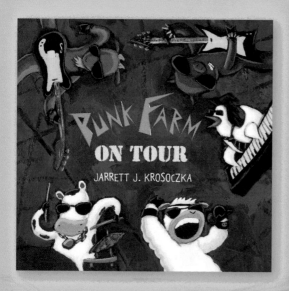

Punk Farm On Tour
October 9, 2007
Knopf Books for Young Readers

When I finished the very last painting for *Punk Farm*, I knew I wasn't done with Sheep, Pig, Goat, Cow, and Chicken. I wrote a sequel before the first book was even published, but Knopf wanted to wait and see how that book did in the marketplace first. Lucky for me, it did well enough to warrant a sequel and I sent Punk Farm out on the road in *Punk Farm on Tour*. The band travels across the country and the makeup of their audience changes depending on what region they're in. To research the book, I visited zoos and nature labs and drew the wildlife as they actually exist before giving them spiked jewelry and mohawks. Look closely at the crowd scenes in *Punk Farm on Tour*—with each new show one of their groupies tags along.

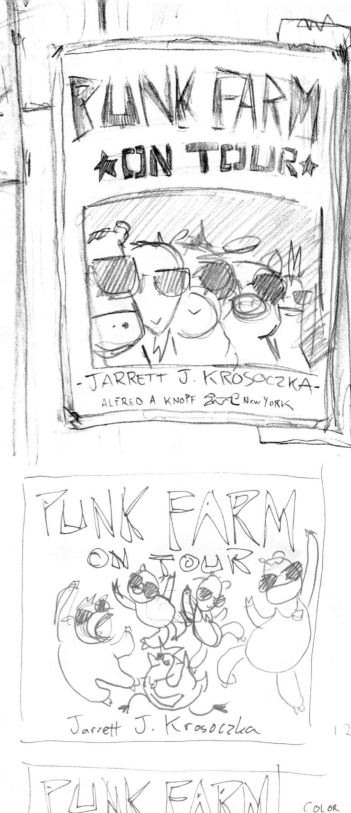

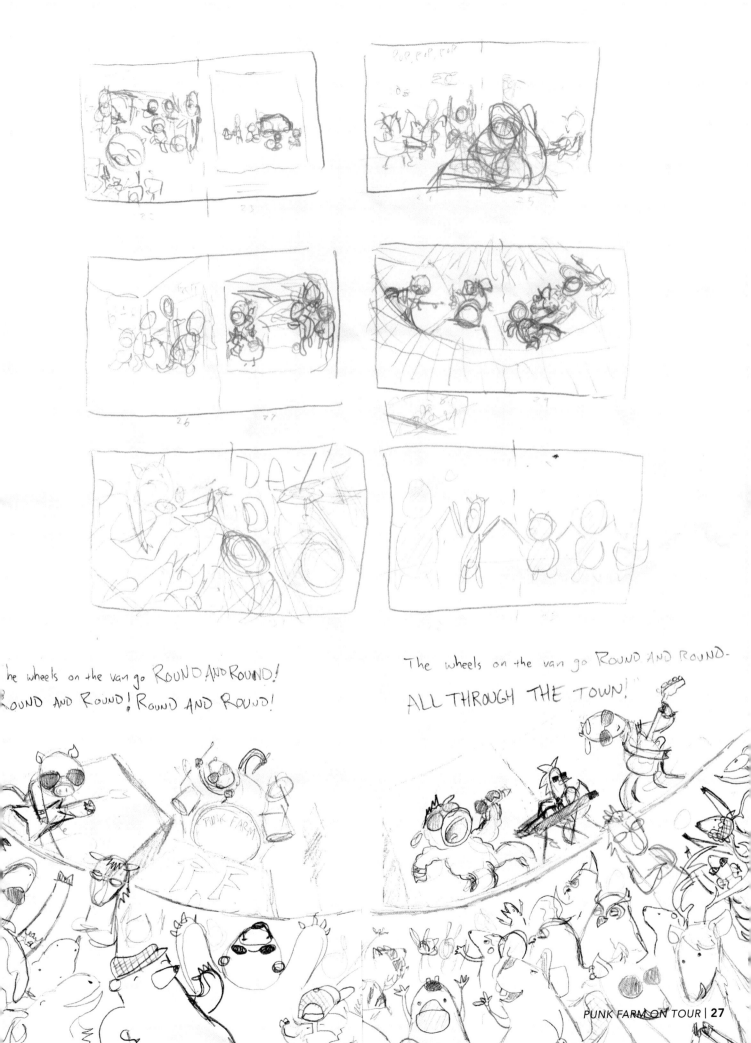

he wheels on the van go ROUND AND ROUND!
ROUND AND ROUND! ROUND AND ROUND!

The wheels on the van go ROUND AND ROUND-
ALL THROUGH THE TOWN!"

Ollie the Purple Elephant
October 11, 2011
Knopf Books for Young Readers

In October of 2007, my wife Gina and I traveled home from our honeymoon in Hawaii. Somewhere over the Pacific Ocean, I opened my sketchbook, turned to my bride, and asked, "What should I draw?" "I don't know," she said. "Draw an elephant." This is when Ollie first appeared within the pages of my sketchbooks. We returned home to start our new lives together and I got to work on my story about an elephant who was searching for his place in the world. I drew other circus animals, like Zoe the Monkey and Leon the Lion. I named the family in the book after our new neighbors in Northampton and the children after the flower girl and ringbearer in our wedding. As my young family grew, the story grew. We brought home a pug named Ralph and welcomed our daughter Zoe into the world. Knopf picked up the book and I got to work on all of the illustrations for it. There is no doubt that my newfound family life influenced this story. And just as Ollie does with the McLaughlin family, we too have impromptu dance parties after dinner. I am ecstatic to be introducing a new picture book character with *Ollie the Purple Elephant*.

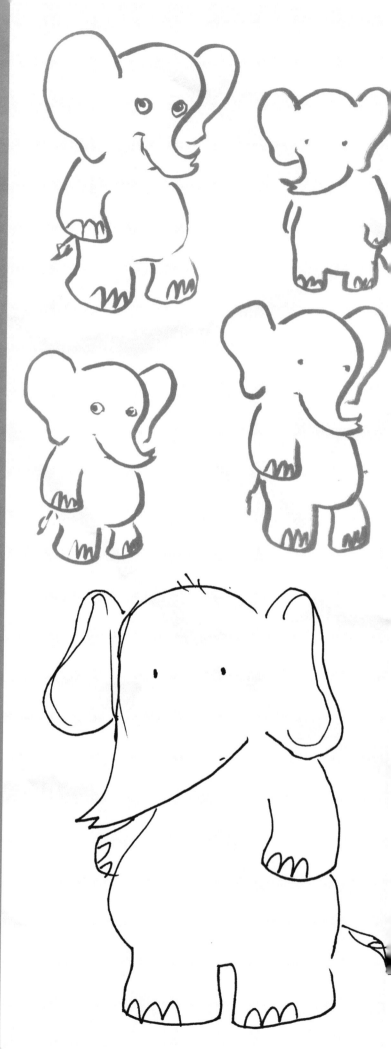

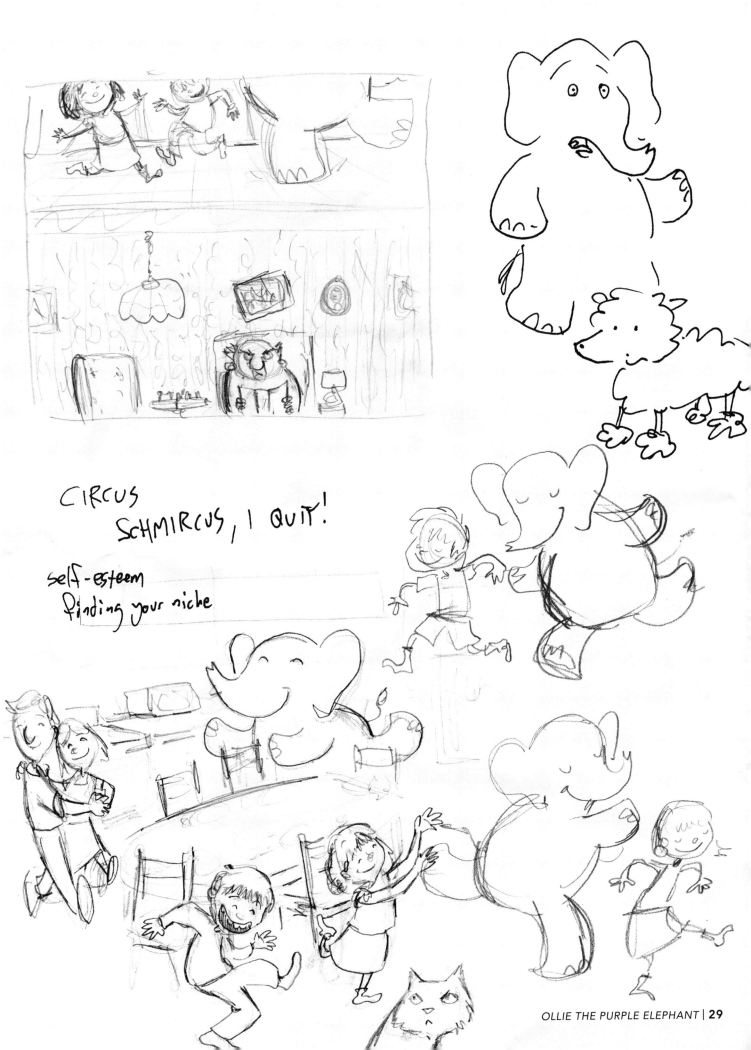

CIRCUS
SCHMIRCUS, I QUIT!

self-esteem
finding your niche

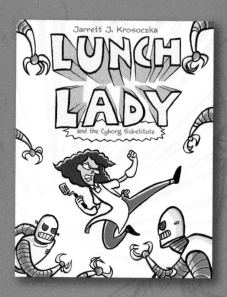
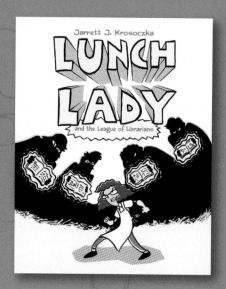
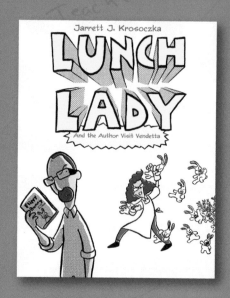
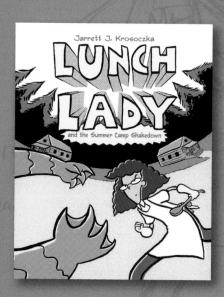
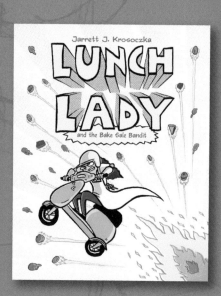
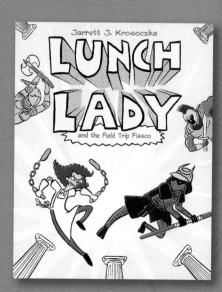

Lunch Lady graphic novel series
Knopf Books for Young Readers

When *Good Night, Monkey Boy* was published, I returned to Gates Lane, my old elementary school in Worcester, MA, to talk to the students about writing and illustrating. When I was there, I ran into Jeanne, my old lunch lady from when I was a kid. She told me what she had been up to and about all of her grandchildren. I was startled. My lunch lady had a life outside of school? She didn't live in the kitchen with the tater tots? What would she do when she wasn't cooking lunch? I first wrote *Lunch Lady* as a picture book and it was more about the different activities the kids dreamed up for their lunch lady's free time, including being a spy who knew karate.

After a failed attempt at a *Lunch Lady* chapter book, I wrote a pitch for *Lunch Lady* as a cartoon, but then backed away from that prospect when I realized I would be giving up all of my intellectual property if the show were picked up. It was at this step, however, when I really fleshed out Lunch Lady's world. I also invented all of the gadgets that Lunch Lady uses, like the Fish Stick Nunchucks and the Spork Phone. I was soon invited to be a part of *Guys Write for Guys Read*. For this compilation, I reillustrated a comic I drew as a kid. I fell back in love with comics, a format I had spent my entire childhood and adolescence working in. And I realized that this would be the ideal book format for my story about a crime-fighting cafeteria worker. I first submitted *Lunch Lady* as a graphic novel to Knopf in 2005. It took a few years to pull together—the first two volumes weren't published until 2009.

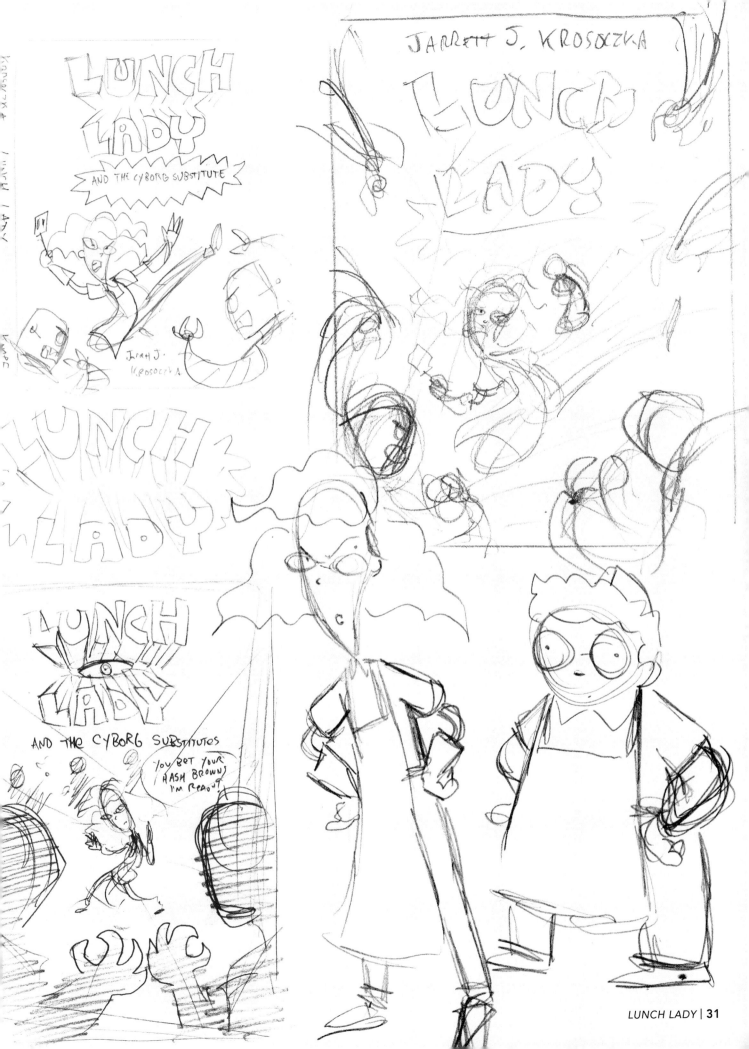

LUNCH LADY

LUNCH LADY, BETTY, AND THE BREAKFAST BUNCH

Originally, Lunch Lady went solo. She was a one-woman operation who fought crime and spit out food-related expletives. But with all of the gadgets I was coming up with for her to use, she needed help. She was a busy woman, her days already filled with serving justice and serving lunch—she didn't have time to invent these tools. I also realized that I needed a young character for my young audience to relate to. At first there was just one student who would sneak out of class and into the boiler room to invent the arsenal of cafeteria-themed weaponry. I split that kid into three characters, each with a distinct personality. Hector, Terrence, and Dee would learn about Lunch Lady's double life, serving as an excellent entry into this world for my young readers. They also serve as a foil to Lunch Lady, who doesn't want kids snooping around and blowing her cover. But this still left Lunch Lady without help. Every decent spy or superhero has somebody behind the scenes helping run the operation. And that's why Betty came into the story. While Betty was initially drawn up to simply design Lunch Lady's Spork Phone and Spatu-copter, she serves as an integral story element. The conversations Lunch Lady has with her trusty colleague help move the stories forward.

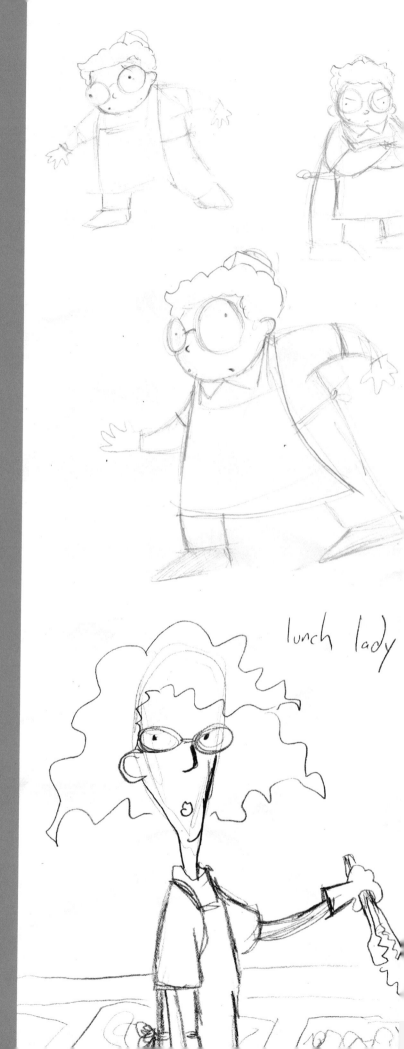

lunch lady

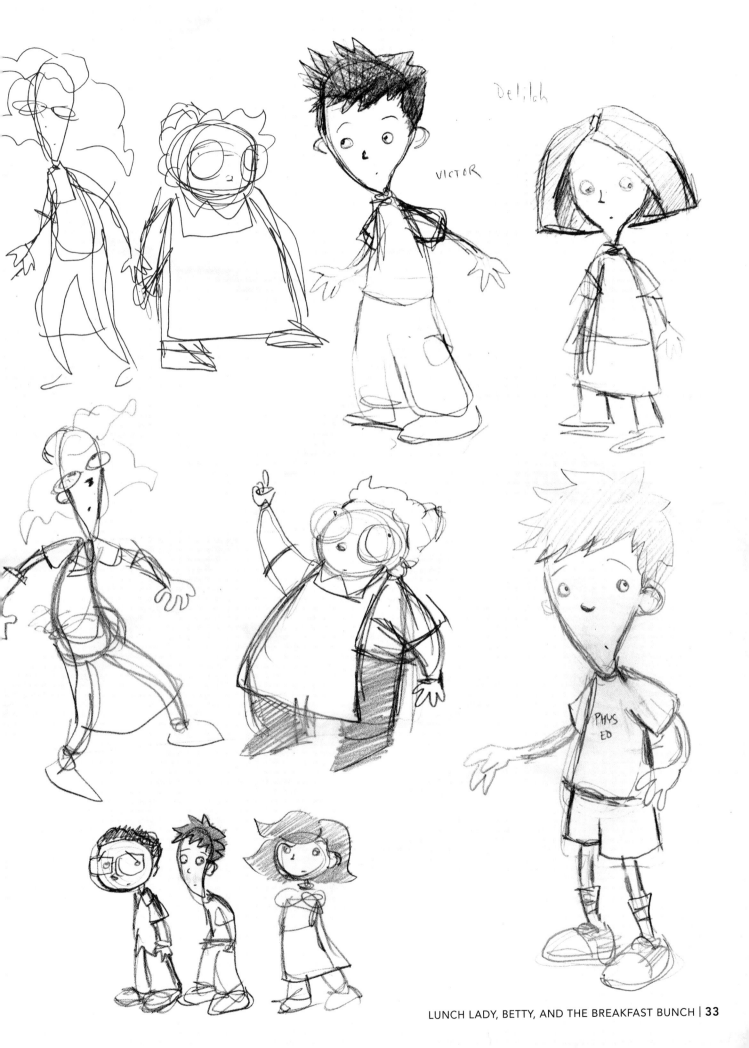

Delilah

VICTOR

LUNCH LADY

VILLAINS

If the school lunch lady was to be the story's superhero, the other staples of school life would be the supervillains and the capers would all be schoolcentric. Something is up with the substitute teacher! What are those librarians up to? Does the visiting author live in a mansion? At the same time, I didn't want every book in the series to take place at school. If every story took place within the school's walls, things would get repetitive and dull very quickly. I would need to find creative ways to take the heroes beyond school grounds. I sent them off to summer camp and on a field trip—things were bound to go awry! I've also planted seeds for future stories in each title. While you don't need to read the books in order, if you do, you'll find a lot of foreshadowing. Recognize that bus driver in *Lunch Lady and the Summer Camp Shakedown*? Did you see what children's books were for sale at the book fair in *Lunch Lady and the League of Librarians*? And not all references are from the very next book in the series. There are a lot of little details that have been sprinkled throughout. Dedicated readers will soon be rewarded for their attentiveness!

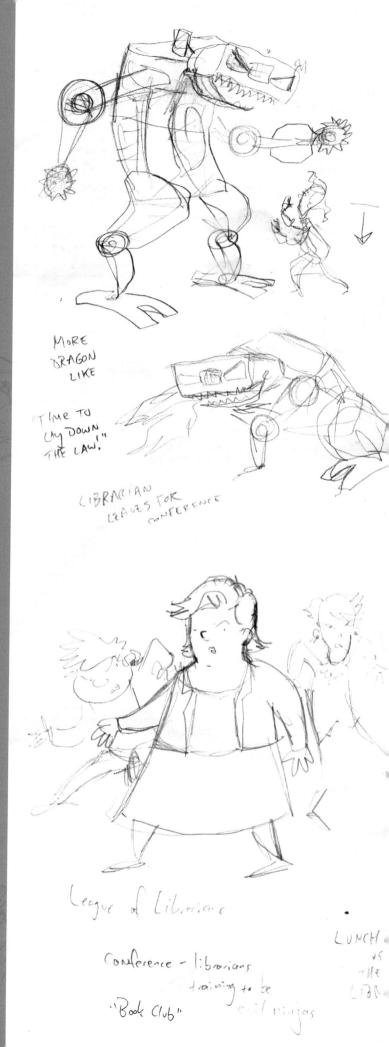

MORE DRAGON LIKE

"TIME TO LAY DOWN THE LAW!"

LIBRARIAN LEAVES FOR CONFERENCE

League of Librarians

Conference - librarians training to be ...

"Book Club"

LUNCH vs the LIBR...

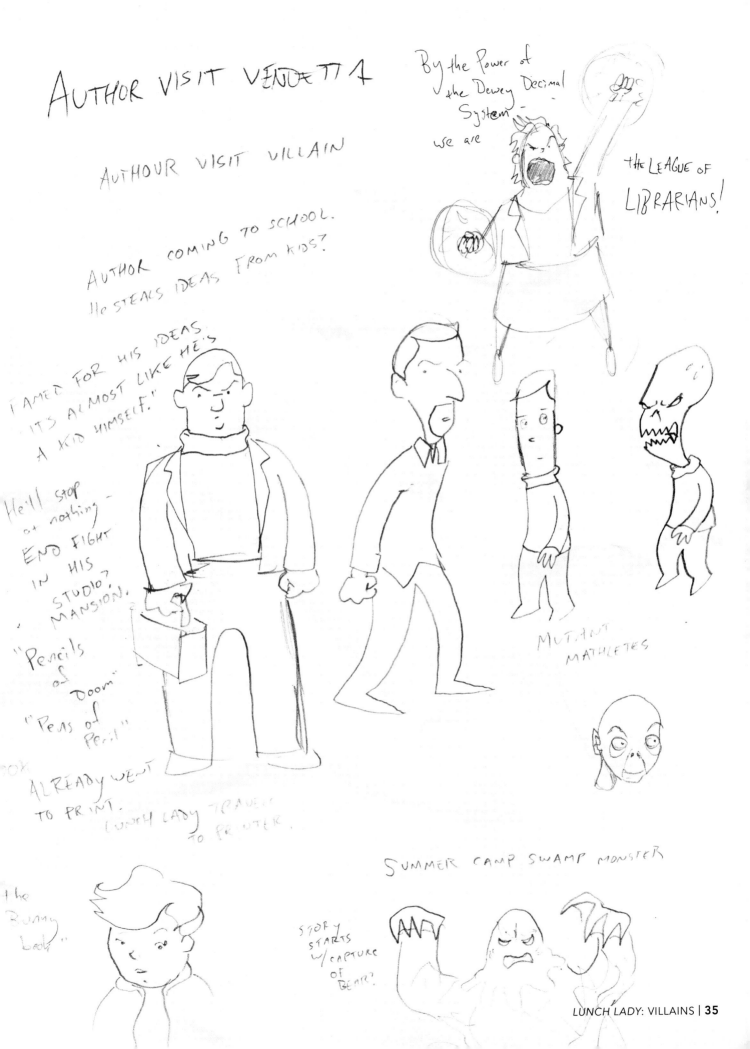

AUTHOR VISIT VENDETTA

AUTHOUR VISIT VILLAIN

AUTHOR COMING TO SCHOOL.
He STEALS IDEAS FROM KIDS?

By the Power of
the Dewey Decimal
System -
we are

THE LEAGUE OF
LIBRARIANS!

FAMED FOR HIS IDEAS.
"ITS ALMOST LIKE HE'S
A KID HIMSELF."

He'll stop
at nothing -
END FIGHT
IN HIS
STUDIO?
MANSION.

"Pencils
of
Doom"
"Pens of
Peril"

ALREADY WENT
TO PRINT.
LUNCH LADY TRAVELS
TO PRINTER.

The
Bunny
Lady"

STORY
STARTS
W/ CAPTURE
OF
BEAR?

MUTANT
MATHLETES

SUMMER CAMP SWAMP MONSTER

LUNCH LADY

GADGETS

If you saw your lunch lady walking down the halls with nunchucks, you'd begin to ask some serious questions. If you saw your lunch lady walking down the hall with fish sticks, you wouldn't think twice about it. This was my thought process behind inventing Lunch Lady's gadgets. Once I hit upon this aspect of the story, I went to town—and I had a blast doing so. First I would start with the item. What could a spork do? Well, it would be a phone, obviously. A lunch tray would transform into a laptop computer; a milk carton with a bendy straw would become a spy camera. As I developed the plots in the books, I worked the other way around. Lunch Lady needed to see in the dark; what could be used as night-vision goggles? Tacos! (Obviously!) It has definitely been a difficult task to invent new gadgets for the later titles. They need to keep up with the originality of the early ones and there are only so many items that can be found in a cafeteria. But kids themselves send me the most ingenious ideas. A reader once suggested I use macaroni and cheese. Why hadn't I thought of that?! Macaroni and cheese is a cafeteria staple and it's yellow! So obvious, I didn't even see it.

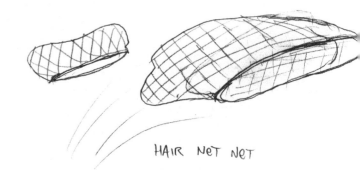

HAIR NET NET

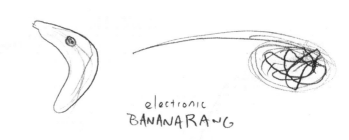

electronic
BANANARANG

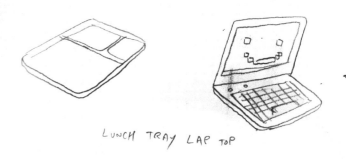

LUNCH TRAY LAP TOP

SPAT-U-COPTER

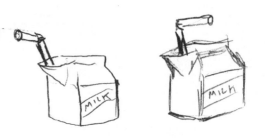

MILK-CAM 5,000

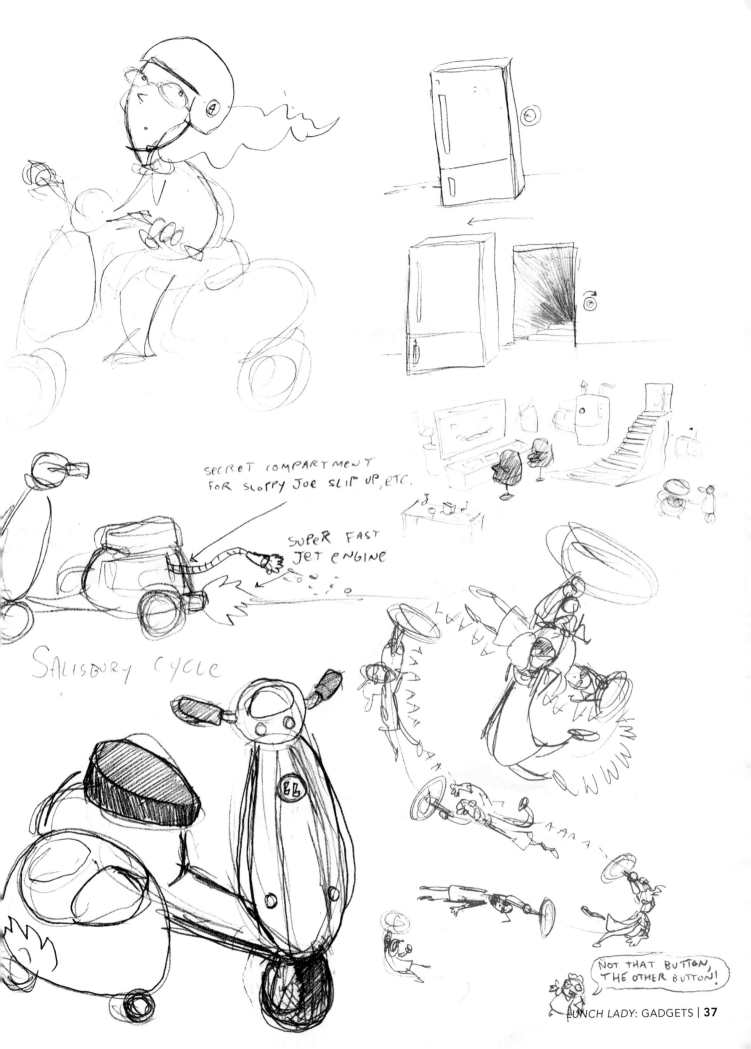

SECRET COMPARTMENT
FOR SLOPPY JOE SLIP UP, ETC.

SUPER FAST
JET ENGINE

SALISBURY CYCLE

NOT THAT BUTTON,
THE OTHER BUTTON!

UPCOMING PROJECTS

As I celebrate ten years as a published author and illustrator, I am hard at work on future titles. There's a seventh and an eighth *Lunch Lady* in the works, as well as ideas for titles beyond that! My eleventh picture book will be called *Peanut Butter and Jellyfish*; it's about a sea horse and a jellyfish who are best friends. I'm also embarking on a new chapter of my career (pun intended) with a middle-grade chapter book series called *Platypus Police Squad*. In 2013, you will meet seasoned vet Detective Corey O'Malley and his new partner, hot-shot rookie Detective Rick Zengo, in *Platypus Police Squad: The Frog Who Croaked*. And if all goes well, *Punk Farm* may make it to the silver screen after all. MGM is currently developing an animated movie based on my punked-out barnyard quintet.

It's hard to believe it has been a decade since my literary debut. Since then, I have traveled the country a dozen times over, visiting countless schools, libraries, and bookstores. I have made the most incredible friends in this journey. It's a list that is both staggering and humbling, filled with passionate educators, avid book lovers, dedicated booksellers, and fellow authors—both those whose work inspired me as a kid and those who have risen in the ranks alongside me. For those of you reading this, I cannot even begin to thank you enough for your support. Whether you've been there since the start or only just recently, your enthusiasm for my work has made my boyhood dreams a reality. I am a truly fortunate man who gets to use his imagination as his full-time job. I look forward to many more years of bringing you my words and pictures. It's funny—ten years in and I feel like I'm only getting started.

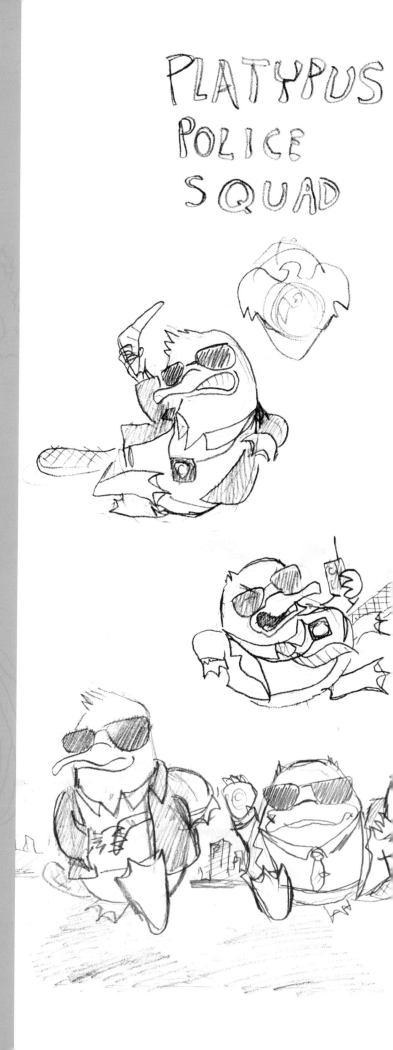

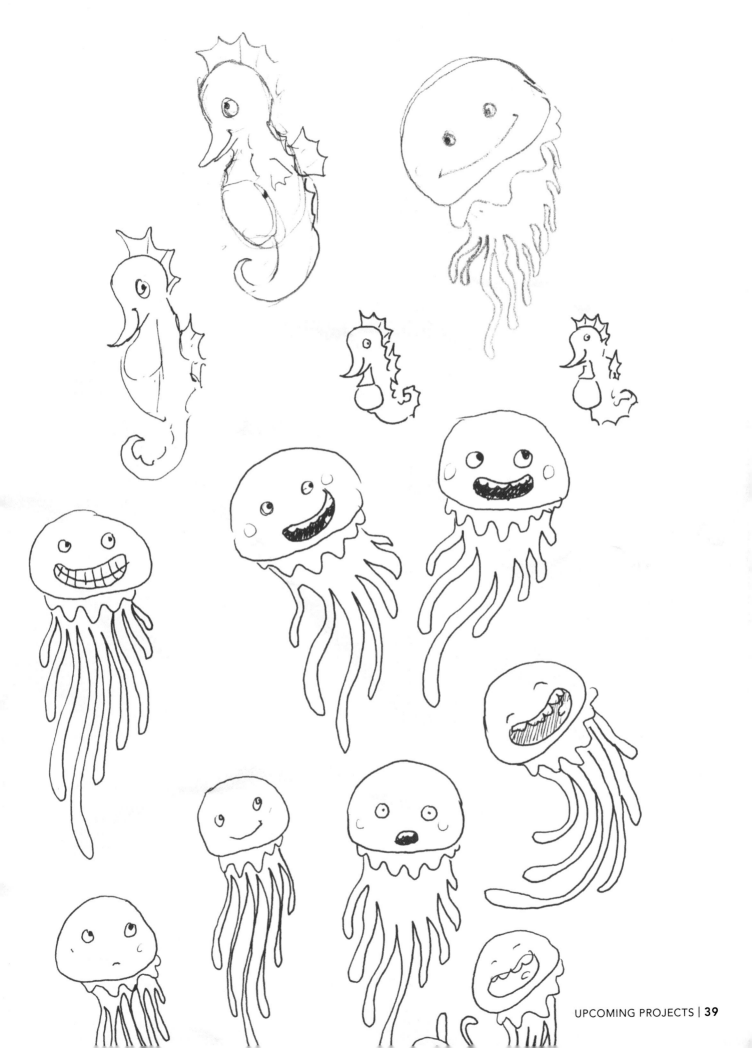

JARRETT J. KROSOCZKA used to be a goofy kid who liked to draw. Now, he is an award-winning published author/illustrator with many books to his credit. Growing up in Worcester, MA, Jarrett drew relentlessly and always had a cast of characters that he wrote stories for. Six months after graduating from the Rhode Island School of Design, Jarrett landed a contract for his first book as an author and illustrator. *Good Night, Monkey Boy* was published on June 12, 2001, and was followed by the publication of more picture books—*Baghead; Bubble Bath Pirates!; Annie Was Warned; Max for President; Punk Farm; Giddy Up, Cowgirl; My Buddy, Slug;* and *Punk Farm on Tour.* He is also the creator of the *Lunch Lady* graphic novel series, which has six titles in print.

Jarrett is an Eisner Award nominee and the two-time winner of a Children's Choice Book Award. In 2003, *Print* magazine selected Jarrett as one of their top 20 new visual artists under 30. His work has landed on numerous state reading lists and has been short-listed by *Newsweek, USA Today, The Boston Globe,* and *The New York Times. Punk Farm* and the *Lunch Lady* series are both currently in development as feature films.

With new book projects on the horizon, Jarrett is happily living out his childhood dream in Northampton, MA, where he resides with his wife and daughter and their pug, Ralph Macchio.

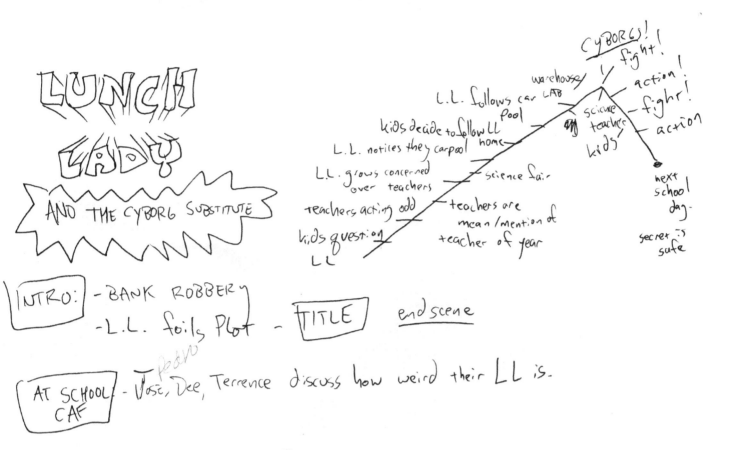

PICTURE BOOKS

Good Night, Monkey Boy—June 12, 2001, Knopf Books for Young Readers
Baghead—September 10, 2002, Knopf Books for Young Readers
Bubble Bath Pirates!—March 10, 2003, Viking Children's Books
Annie Was Warned—August 26, 2003, Knopf Books for Young Readers
Max for President—July 13, 2004, Knopf Books for Young Readers
Punk Farm—April 26, 2005, Knopf Books for Young Readers
Giddy Up, Cowgirl—February 2, 2006, Viking Children's Books
My Buddy, Slug—September 12, 2006, Knopf Books for Young Readers
Punk Farm On Tour—October 9, 2007, Knopf Books for Young Readers
Ollie the Purple Elephant—October 11, 2011, Knopf Books for Young Readers

GRAPHIC NOVELS

Lunch Lady and the Cyborg Substitute—July 28, 2009, Knopf Books for Young Readers
Lunch Lady and the League of Librarians—July 28, 2009, Knopf Books for Young Readers
Lunch Lady and the Author Visit Vendetta—December 22, 2009, Knopf Books for Young Readers
Lunch Lady and the Summer Camp Shakedown—May 11, 2010, Knopf Books for Young Readers
Lunch Lady and the Bake Sale Bandit—December 28, 2010, Knopf Books for Young Readers
Lunch Lady and the Field Trip Fiasco—September 13, 2011, Knopf Books for Young Readers

UPCOMING PROJECTS

Lunch Lady and the Mutant Mathletes—2012, Knopf Books for Young Readers
Lunch Lady and the Picture Day Peril—2012, Knopf Books for Young Readers
Peanut Butter and Jellyfish—2013, Knopf Books for Young Readers
Platypus Police Squad: The Frog Who Croaked—2013, Walden Pond Press

DEDICATED TO
YOU, THE READER

Before I get into the acknowledgments, I need to point out that designer John Lind has done a remarkable job in putting this book together. John poure
through fifteen years worth of sketchbooks and organized them in a clever, handsome fashion. That, and he's a great guy. And he's humble. I enjoy the
thought of him begrudgingly including this paragraph in the layout of this book.

OK, now on to the acknowledgments.

It all began with Joe and Shirl, who supported me from the start. Whether it was supplying me with paper and pencils on long car trips or having the
courage to send me to art school, they always believed in me. Thanks to my entire family who encouraged me all along the way. (If you're wondering wh
those names are in each individual book's dedication—that's them.) Thank you to the many teachers who gave me their all, like Mrs. Alisch in first grade
and later Mrs. Casey and Mr. Shilale in high school. Many thanks to Mark Lynch, who, at the Worcester Art Museum, instructed me to "forget everything
had learned" upon hearing that I had read a "How to Draw" book. (The single greatest piece of artistic advice I have ever been given.) At RISD, Mary Ja
taught me color, Oren instilled a love of pattern, and Judy Sue pushed me to paint my characters.

I will be forever grateful to Tracy Gates, who picked up a postcard in the fall of 1999 and invited me in to Random House Children's Books to show my
work. Isabelle Warren-Lynch, Melissa Greenburg, and Jinna Shin, you make my books look purty. Michele and Kelly, you've kept things moving. Dominiq
and everyone in publicity and marketing, thank you for getting the word out. Tracy, Adrienne, and everyone in the School/Library department, we'll alwa
have Texas. Thanks to everyone in production for matching the color combinations I paint and everyone in copyediting for figuring out how to correctly
spell "Spatu-copter." And of course, thank you to the remarkable, amazing, and whip-smart Michelle Frey. I couldn't ask for a better cheerleader or story
shaper. You always know how to get the best story out of me.

Jordan Brown at Walden, I look forward to hitting the beat with you. Thus far, the Academy has been tremendous!

Thank you to Grace Lin, who gave me a key piece of advice early on, and the many authors and illustrators who have offered camaraderie along the way.

To all of the booksellers: your recommendations and hand-selling to customers are why I am able to write and illustrate books for a living. I have loved
visiting your stores over these past ten years and I look forward to visiting again in the next ten years and beyond! Thank you for being such passionate
book lovers.

To all of the librarians: you are on the front lines of building a literate society and our world would crumble without you. Your ingenuity and creativity
inspires me. Whether I've visited your library or your cyberspace, I thank you.

There are so many educators I need to acknowledge, but I would be remiss if I didn't mention Heather Jankowski and her "league of librarians" in Cy-Fai
Dr. Joan Kindig, Dr. Karen Huff, Cathy Bonnell, Fuse #8, Rocco, Jules & Eisha, and @MrSchuReads.

Thank you to Robin and everyone at the Children's Book Council for putting my name in lights and for putting up with my antics. (There will be plenty mo
to come!)

They hate the attention, but Rebecca Sherman at Writers House and Eddie Gamarra at The Gotham Group work so hard for me. Thank you for your dili-
gence and your friendship.

But wait—I saved the best for last. To my beautiful and adoring wife, Gina, thank you for putting up with a husband who travels and has book deadlines.
And thank you for your honesty. If a story of mine is a dud, I need look no further than your reaction. (Even if I get huffy at first, I appreciate it.) I love you
To my daughter Zoe and her sibling(s) to come—I hope you enjoy reading about how Daddy gets his ideas. I look forward to the inspiration that you will
most certainly provide in the years ahead. (And yes, thank you to Ralph, who keeps me company in the studio and only asks for the occasional rawhide.)

MONKEY BOY TO LUNCH LADY:
THE SKETCHBOOKS OF JARRETT J. KROSOCZKA

BY JARRETT J. KROSOCZKA
DESIGNED BY JOHN LIND/www.linddesignco.com
COPYEDITED BY ELLEN MANNING

ILLUSTRATION AND TEXT © 2011 JARRETT J. KROSOCZKA; INTRODUCTION © 2011 MARK LYNCH

FOR MORE INFORMATION AND UPDATES ON THE WORK OF JARRETT J. KROSOCZKA, PLEASE VISIT www.studiojjk.com

PRINTED COPIES OF THIS PUBLICATION ARE AVAILABLE FROM http://www.studiojjk.com/10yearssketchbook.html

FIRST EDITION: OCTOBER 2011

(eBOOK) ISBN: 0-9838545-0-5; ISBN13: 9780983854517
(Paperback) ISBN: 0-9838545-1-3; ISBN13: 9780983854517

CPSIA information can be obtained
at www.ICGtesting.com
Printed in the USA
LVIC06n0345221113
362358LV00006B/18